BICYCLE

BICYCLE

BY PAUL FATTARUSO

with original drawings

BY ADAM THOMPSON

HOTEL ST. GEORGE PRESS
BROOKLYN, NEW YORK

Cover Design by Predella (www.predella.net)
Cover Drawings by Adam Thompson

Published by Hotel St. George Press

ISBN 13: 9780978910327
Library of Congress Control Number: 2007943792

First Printing

Hotel St. George Press
Book a room.
www.hotelstgeorgepress.com

For Max

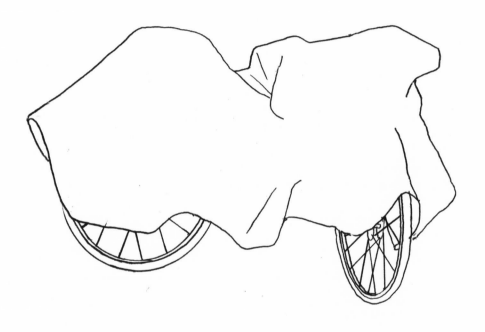

BICYCLE

Do you prefer the machinery of the bicycle, or the softer machinery of a bird?

Paul Fattaruso

If the bicycle squeaks, that means something is trying to kill it, however patiently.

BICYCLE

Its momentary translucence at dawn, when the bicycle is made of ash.

Paul Fattaruso

A bicycle might hide in any tall field—say, a field of chest-high corn. Then at harvest time, it sneaks back to its home.

BICYCLE

Twice a year the air carries that faint whir of migrating bicycles.

Paul Fattaruso

Like an angel, the bicycle is born with an innate choreography,
which it cannot fail to understand.

Paul Fattaruso

For many years my grandfather has spent clear nights in the backyard, trying to pick out the constellation of the silver bicycle.

Though it does not complain, my bicycle is clearly
uncomfortable on the couch.

Paul Fattaruso

As if in a trance, I wander into the bear's den, and there in a
dim corner is my long lost first bicycle, unharmed.

BICYCLE

The sky must be thinking of bicycles. Every cloud is shaped like the aftermath of a bicycle.

BICYCLE

The bicycle wears its bell like a relic, cursed and beloved.

Paul Fattaruso

The bicycle wears its bell like a drop of venom, a berry of thunder.

BICYCLE

I ride my bicycle to the edge of town and find a spot in the shade. The time has come to polish it.

Paul Fattaruso

We arrive at an intricate crossroads. I hand the compass
over to the bicycle.

BICYCLE

Today's bicycle is amiss; it is an imperfect echo of yesterday's bicycle. Then I notice that I myself am amiss, an imperfect echo of something.

Paul Fattaruso

I awake in a hammock, ink still wet on my lips, holding a
disembodied handlebars.

Paul Fattaruso

For its birthday, I bought my bicycle a pair of gloves, something for it to wonder about through the nighttime.

Consider the bicycle of paradise, its meerschaum frame, its wheels of feathers.

Paul Fattaruso

The catfish inspect their new underwater bicycle, and each one privately speculates about its rider, who is nowhere to be found.

BICYCLE

My sister's bicycle bursts into flame there in the front yard, and burns like that for a few weeks, disrupting the whole neighborhood's dreamlife.

Paul Fattaruso

With a little doctoring, a bicycle can indeed be made to gallop.

BICYCLE

Of all the hidden cities, the city of abandoned bicycles is the most perfectly hidden. One can listen a long time to the indistinct whispers of abandoned bicycles in the streets.

Paul Fattaruso

By all means hang your bikini on my bicycle.

BICYCLE

A red mouse, born in a bicycle tire, at last chews its way into the larger world.

Paul Fattaruso

Two brothers. One rides the same bicycle over many roads, the other rides many bicycles over the same road.

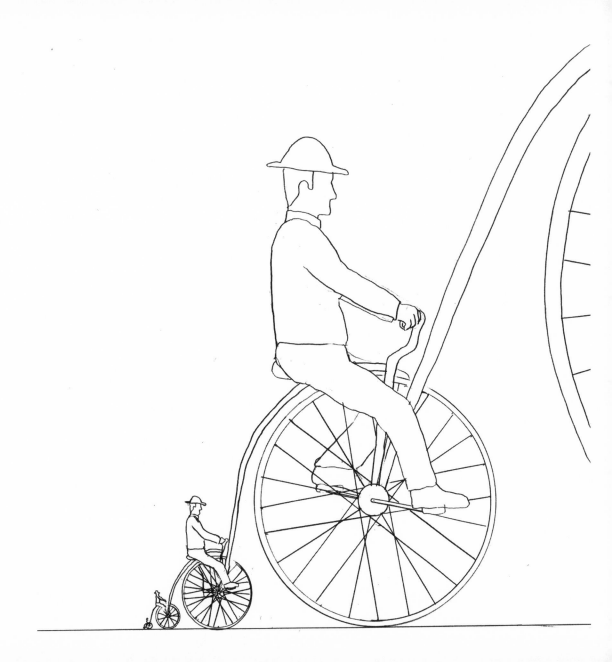

Paul Fattaruso

Within that heap of lawn clippings may well be an excellent bicycle.

BICYCLE

The assassin carried a quiverful of arrows, a strip of jerky,
and rode the shadow of a stolen bicycle.

Paul Fattaruso

We traveled like this for two quiet weeks: only the sound of
wind purring in the spokes of our wheels.

.

BICYCLE

After too long apart, I discover my bicycle has grown a fine layer of down, which stands on end in the cool of a late winter morning.

Paul Fattaruso

Through the quiet of each night, a faint song, the mild squeak of a heartbroken bicycle.

BICYCLE

We come upon the bicycle maker deep in the forest,
lunching on tomato soup, grilled cheese, and a pickle. The
sunlight comes in slivers through the canopy of leaves.

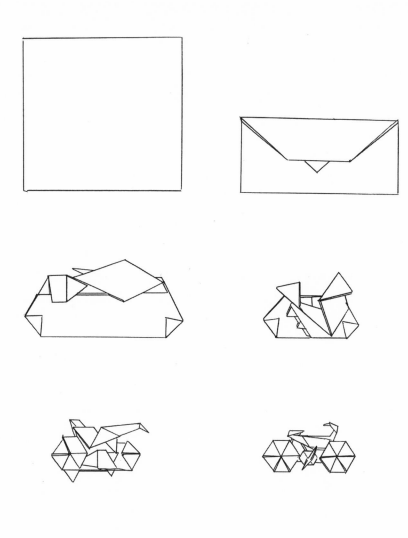

BICYCLE

Suddenly I am certain something is written on the inside of
my bicycle.

In preparation for my voyage across the desert, I attach an enormous sail to my bicycle. On the third morning, I awake to find only the tip of the mast reaching up out of the sand.

BICYCLE

The night of the new moon, all the children adjust their
reflectors.

Paul Fattaruso

After so much time in motion, I have picked up motion's scent. It smells vaguely like the wake of a lightning bolt.

BICYCLE

Down Main Street comes a bicycle painted the color of genuine lemonade.

Paul Fattaruso

The carpenter lingers in his workshop long after sundown, working on his bicycle. Even the bell is wooden, crafted from old apple wood, and warm to the touch.

BICYCLE

I invert my bicycle, so it can feel the moonlight on its underside.

Paul Fattaruso

Every day she rode gradually along the median, towing her wagonload of ageless and well-mannered babies.

That same summer, they unburied an entire fleet of primitive, fossilized bicycles, completely intact.

Paul Fattaruso

It is the weekend. The physicists and their husbands and wives race their ten-speeds through the halls of the particle accelerator.

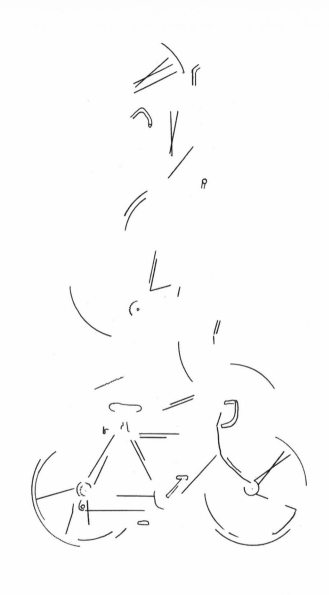

Paul Fattaruso

The cricket-song seemed to come from nowhere. He had disguised himself as the crumbling brake of a dying bicycle.

BICYCLE

To make a living, one must leave in the morning upon one's bicycle, and return in the evening with two bicycles.

Paul Fattaruso

Yes, I miss you. Yes, I am pedaling.

BICYCLE

I woke with a goldfinch on my chest. It had nested on my saddle, a nest like a child's hand, and artfully balanced.

Paul Fattaruso

A bit of rainwater clung to my bicycle, though it had not
yet rained.

BICYCLE

The bicycle consumes itself, and does not diminish, and goes on consuming itself.

Paul Fattaruso

I catch a first glimpse of that distant moment when the bicycle will cease to be new; immediately the distant moment arrives when the bicycle ceases to be new.

BICYCLE

At three o'clock, the cuckoo emerges perched on a bicycle seat. By four o'clock, the cuckoo seems to have fallen from the bicycle.

Paul Fattaruso

We take turns with the stethoscope, listening to the hush of its interior.

BICYCLE

Note the fine red bicycle leaning on the sunny side of the outhouse.

Paul Fattaruso

The bicycle cannot know it is a bicycle. It cannot even suspect.

Romance. A bicycle parked on a slope.

Bicycle

I held it by its stem like a tulip, its two wheels spinning ornamentally in the breeze.

Paul Fattaruso

The bicycle wears its gravity like a massive feather headdress,
waiting for the right wind in which to again take flight.

BICYCLE

We hear it coming long before it crests into view, the grumbling
in the exhausted mechanisms of the executioner's bicycle.

Paul Fattaruso

What I have taken for a bicycle turns out to be a salamander,
pink with black spots. Still, he seems to think like a bicycle.

BICYCLE

I ride each night through the near darkness, the moon as my compass, with the faith that it will lead me back where I came from at exactly the right moment.

Paul Fattaruso

When there is no moon, I ride by instinct, the instinct that quivers in my elbows.

My bicycle moves always patiently. Its mother was a magnificent birdcage; its father was a grandfather clock.

Paul Fattaruso

How easily one commits its fragile balance to memory.

BICYCLE

Already noon, and still the sunlight is thin as Bible paper;
women ride through the streets in their nightgowns.

Paul Fattaruso

For three days an owl sat perched on the crossbar, and I couldn't come anywhere near it.

Paul Fattaruso

Once again I consider my destination. I've worn its edges to
a smoothness with all my considering.

BICYCLE

Under tires, the road sings out in its hidden language, *sforzando.*

Paul Fattaruso

I disappear with my bicycle into a cloud of moths. By the time I reappear, the bicycle is not even a memory.

BICYCLE

At moonrise, the snow is the same purple as the sky. This is
the secret hour when the bicycle leaves no tracks.

Paul Fattaruso

I am headed to that place where they still dry the laundry
by clothesline.

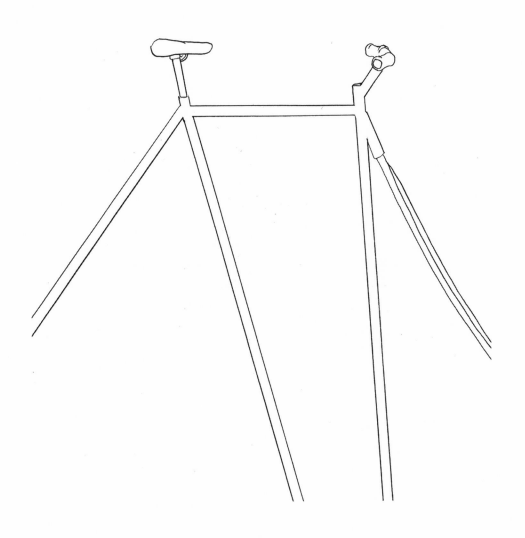

Paul Fattaruso

Once a day, the sun shines to the bottom of the well, and with a carefully angled mirror, you can glimpse down to the decaying bicycle. Try to look directly and your head will cast an obscuring shadow.

BICYCLE

I adjust my tie, straighten my lapels. Today I will ride my bicycle down the great spiral staircase.

Paul Fattaruso

The errant ping-pong ball fells an exhausted bicycle.

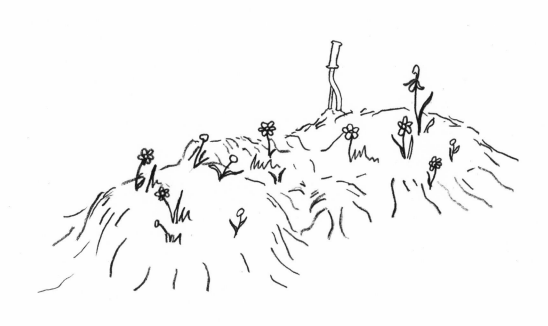

Paul Fattaruso

I watched the tide for years, waiting for the bicycle to wash ashore, that I might scrape away its barnacles, nurse it back, oil it.

BICYCLE

Her freckles describe a bicycle moving too swiftly to touch.

Paul Fattaruso

The bicycle the color of beet juice, the bicycle the color of spilled beet juice.

BICYCLE

The bicycle the color of the hen's foot, the bicycle the color
of her wing.

Paul Fattaruso

The periwinkle bicycle, the bicycle the color of a garbage fire.

BICYCLE

I held the bicycle like an ancient coin, oddly flimsy. I held it
by the scruff of the neck like a baby lion.

PAUL FATTARUSO is the author of *Travel in the Mouth of the Wolf* and *The Submariner's Waltz*. His work has appeared in *Volt, Jubilat, Fence, Black Warrior Review, Another Chicago Magazine, the tiny*, and others. He lives in Massachusetts with his wife Kristin and his son Max. He rides a silver bicycle.

ADAM THOMPSON is an artist and art critic. He lives in Brooklyn with his wife, writer Helen Phillips.

This is the third release from

HOTEL ST. GEORGE PRESS

PLEASE VISIT US ONLINE AT WWW.HSGPRESS.COM

OUR WEBSITE, a literary and arts quarterly, is host to a wide assortment of media—strange films, dubious histories, sonic ephemera and other curious works of fiction and fancy.

OUR PRINT CATALOGUE is an independently curated imprint of Akashic Books. We publish bound narrative objects that wed the playfulness of children's books to the mature content of sophisticated modern prose. Discover our critically acclaimed previous titles:

The Musical Illusionist and Other Tales
by Alex Rose

Disappearing manuscripts. Profane numbers. Extinct bacteria. Cities without shadows. A language spoken entirely in rhythms. A man deaf solely to the waltzes of Chopin. These are among the many anomalies to be found in the Library of Tangents, a vast underground archive whose beguiling exhibitions are detailed by Alex Rose in his exquisite debut collection.

"Rose displays . . . [an] uncanny predilection for masquerading whimsical invention as the most sober of facts."

—*Village Voice*

The Session: A Novella in Dialogue
by Aaron Petrovich

The Session *is a novella in dialogue between two men who share the same name, and who become unable to discern between themselves and one another. Funny and frantic, this work has earned Petrovich comparisons to Beckett, Pinter, Stoppard, and Ionesco.*

"Petrovich draws vivid characters and establishes real tensions seemingly out of thin air."

—*Miami Herald*